LIFE IS SWEET

Coloring Book

Heartfelt Affirmations to Brighten Your Day

Get Creative 6

NEW YORK

Jane Maday

T0016795

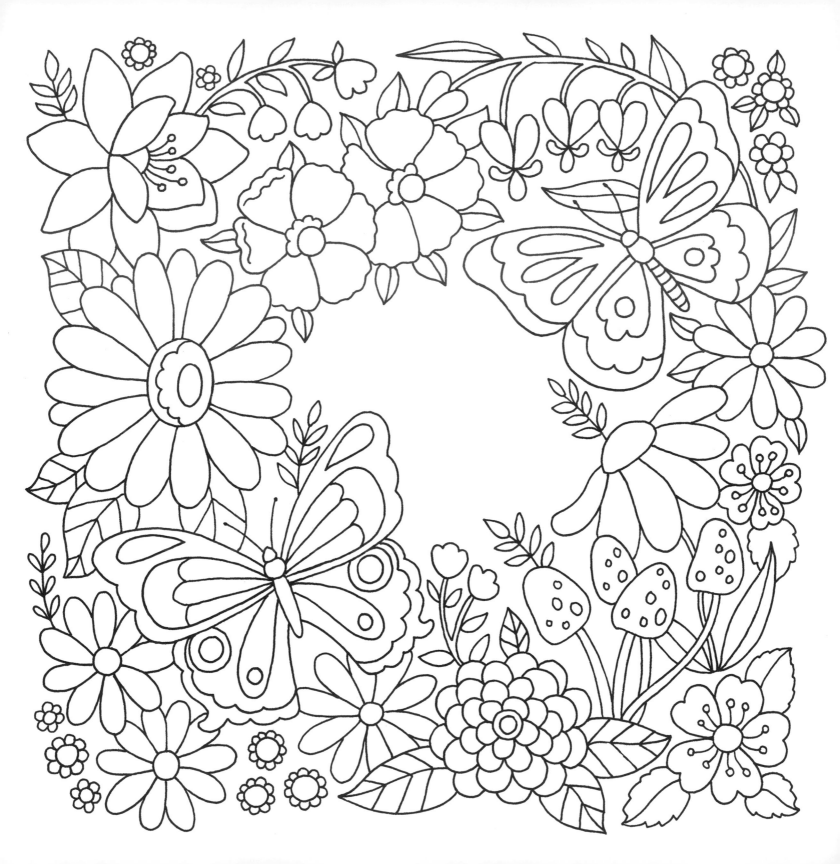

Introduction

Coloring is a wonderful way to find relaxation and express your creativity, no matter your age. It is comforting to lose yourself in art, and many people make coloring a part of meditative practice. Choose whatever materials suit you, such as colored pencils, markers, crayons, or colored pens. I would advise against alcohol markers because they will bleed through the page. Put a protective sheet between the pages if this is the medium you choose. Watercolor will make the pages buckle, so use it sparingly.

There is no right or wrong way to color. Experimenting will help you learn new techniques. Try not to compare yourself to others; coloring is an activity that is just for you and your joy. It can be fun to get together and color with friends, though!

The art in this book was all created by hand. One day I decided I want to "draw a hug." That began a series of drawings that I combined with supportive, comforting words and phrases. Many of the pages are derived from art I created in my personal journal, to express my own feelings. I hope you enjoy coloring these pages as much as I enjoyed creating them.

Happy coloring!

jane maday

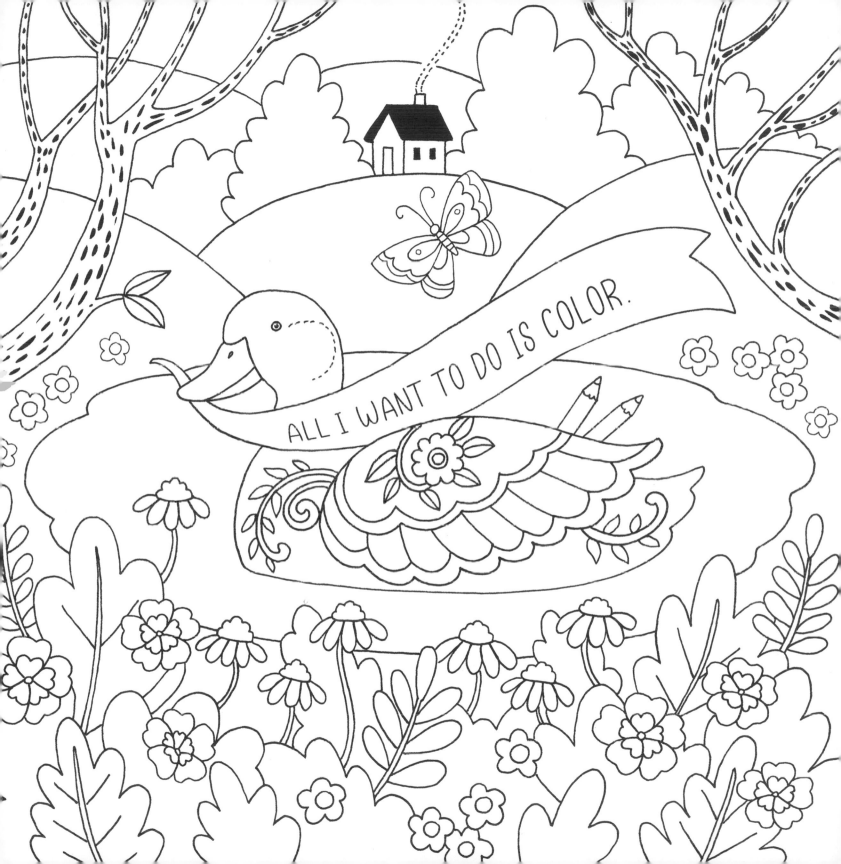

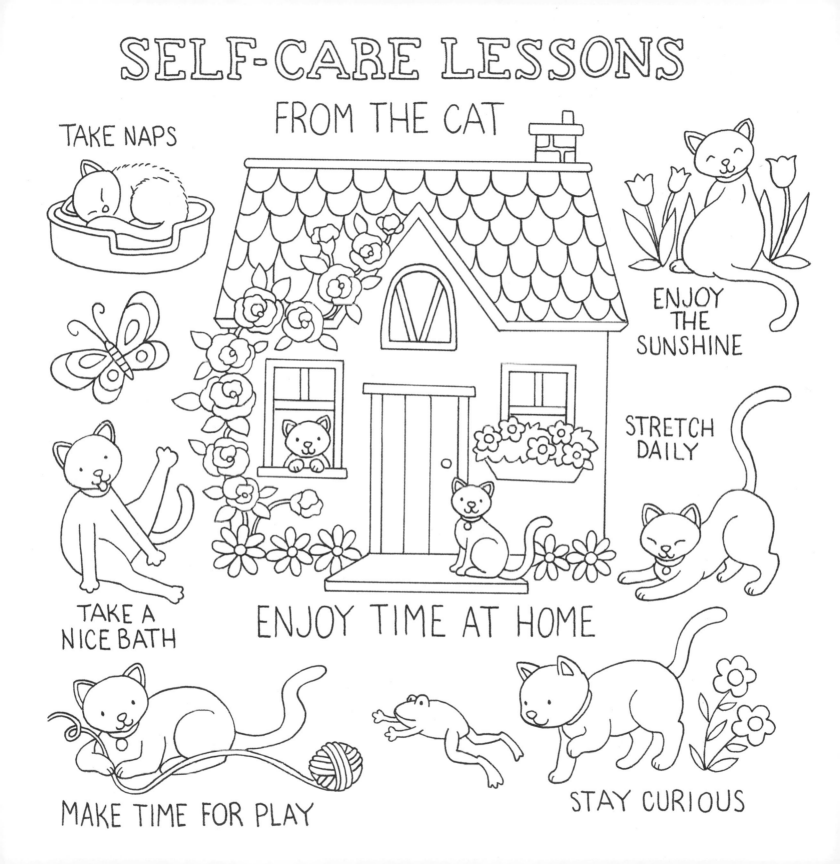

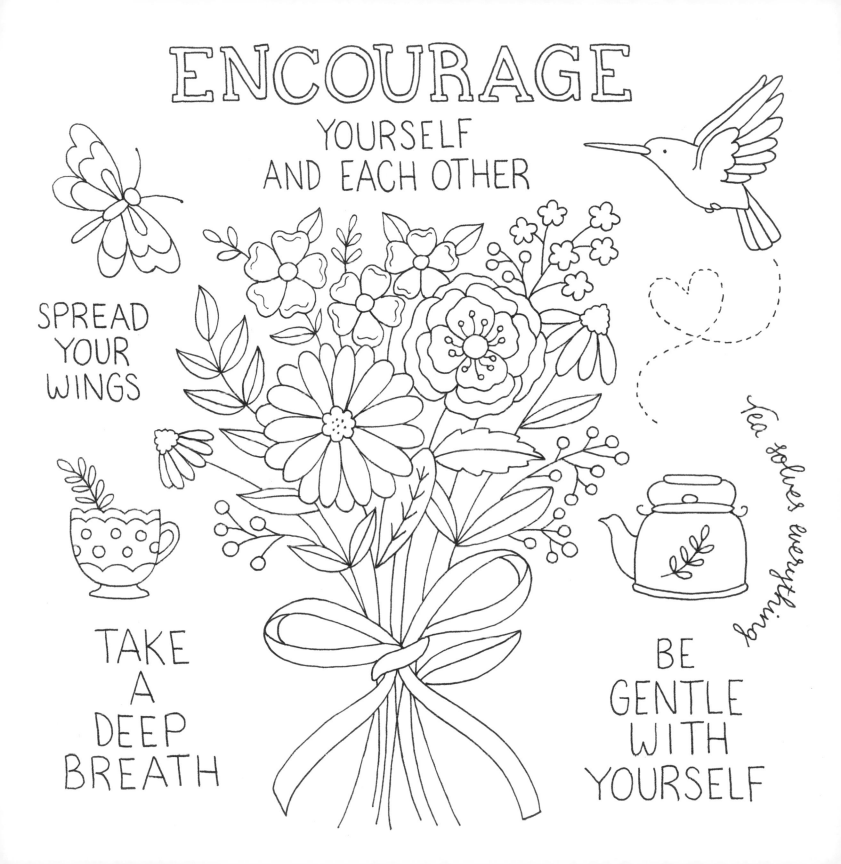

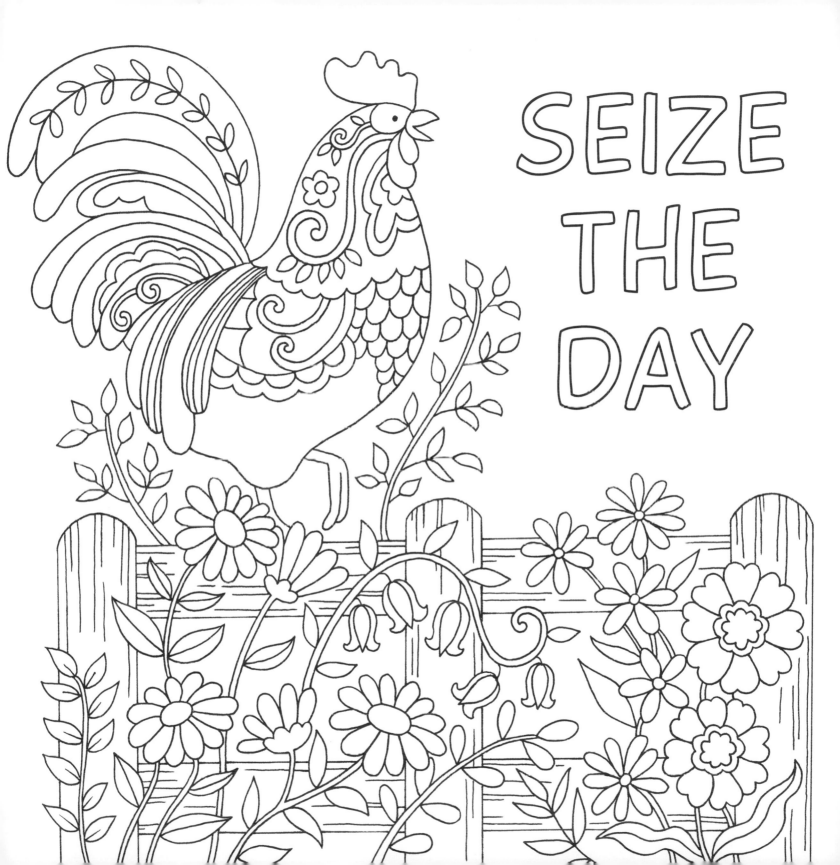

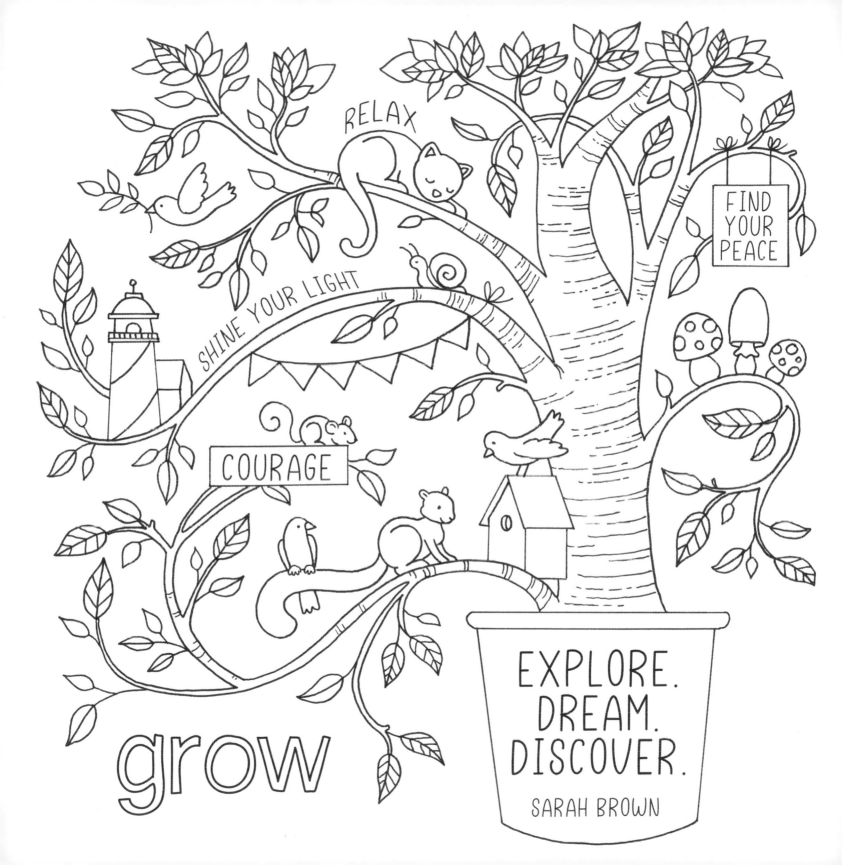

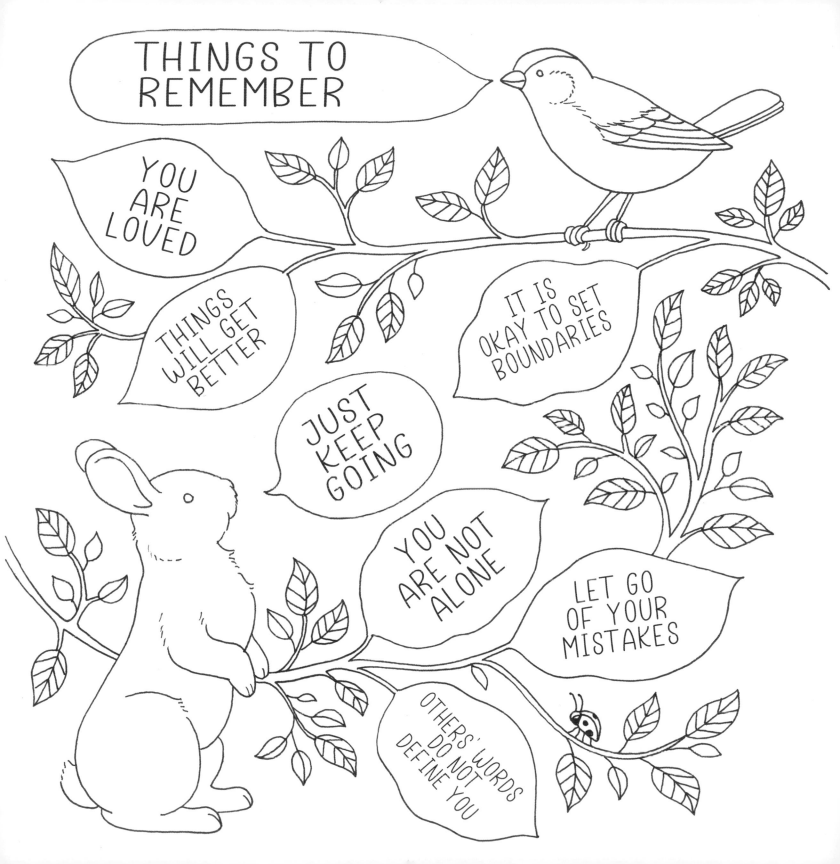

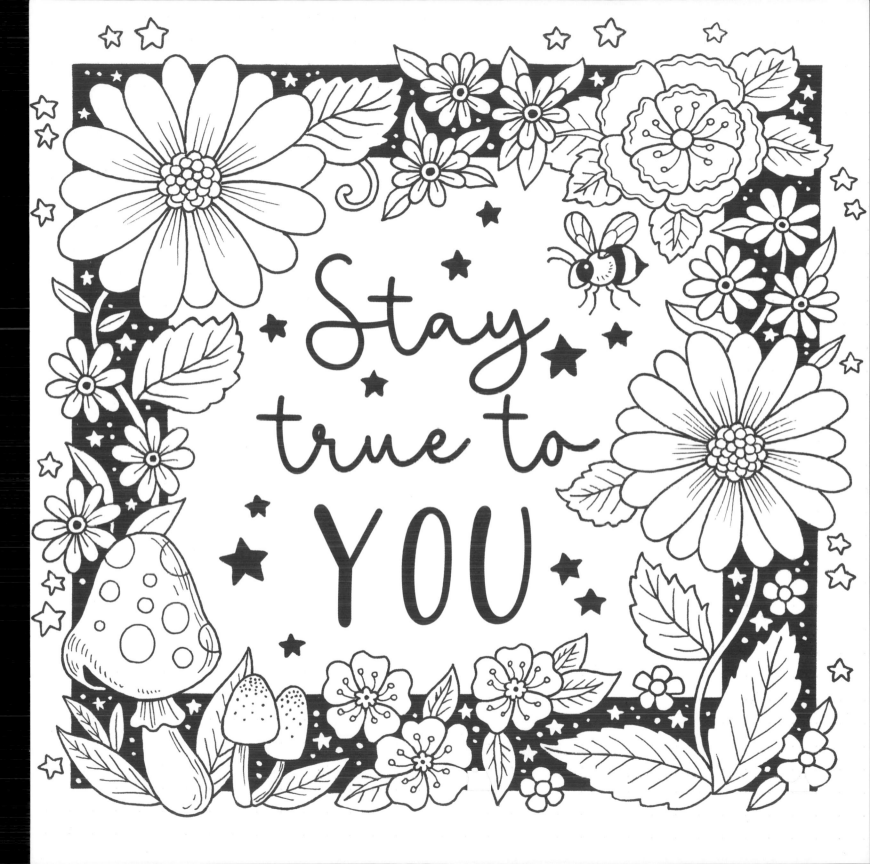

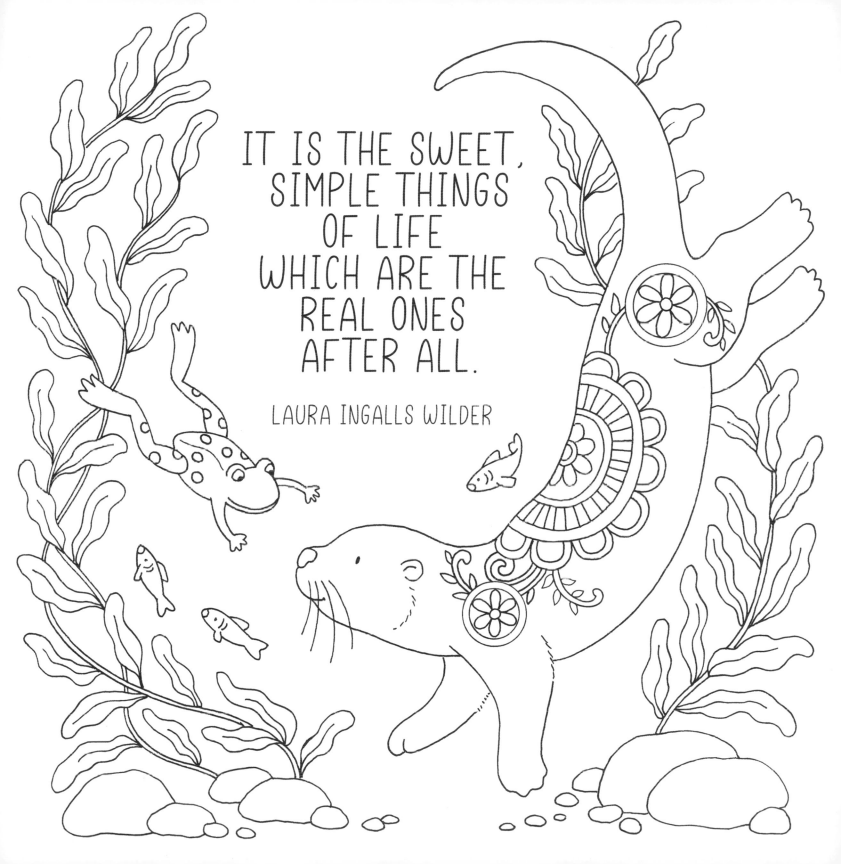

IT IS THE SWEET,
SIMPLE THINGS
OF LIFE
WHICH ARE THE
REAL ONES
AFTER ALL.

LAURA INGALLS WILDER

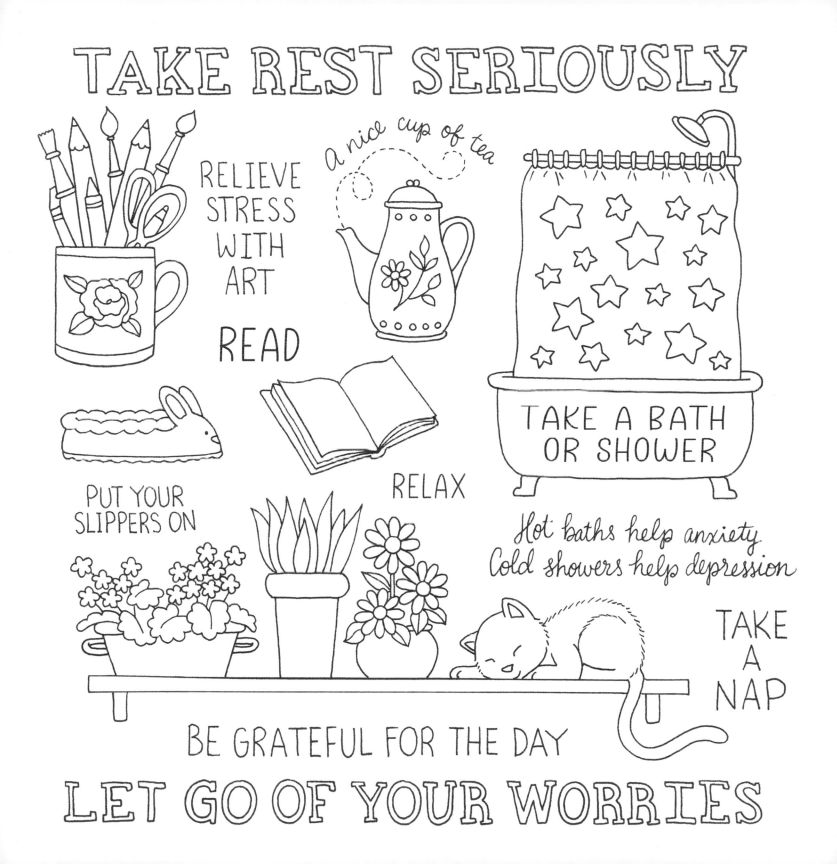

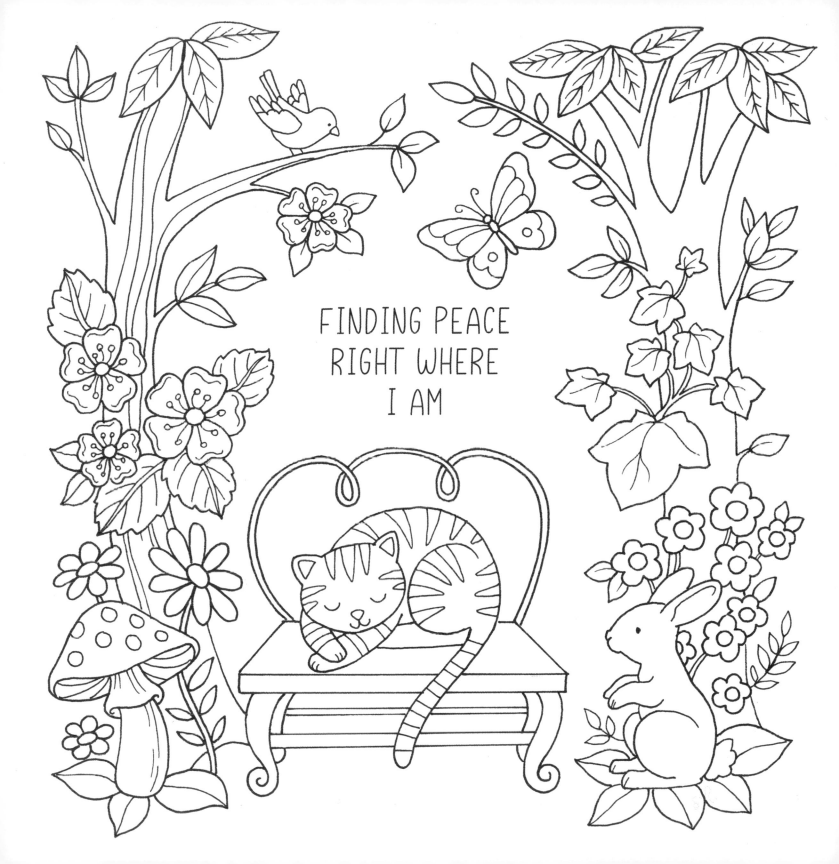

FINDING PEACE
RIGHT WHERE
I AM

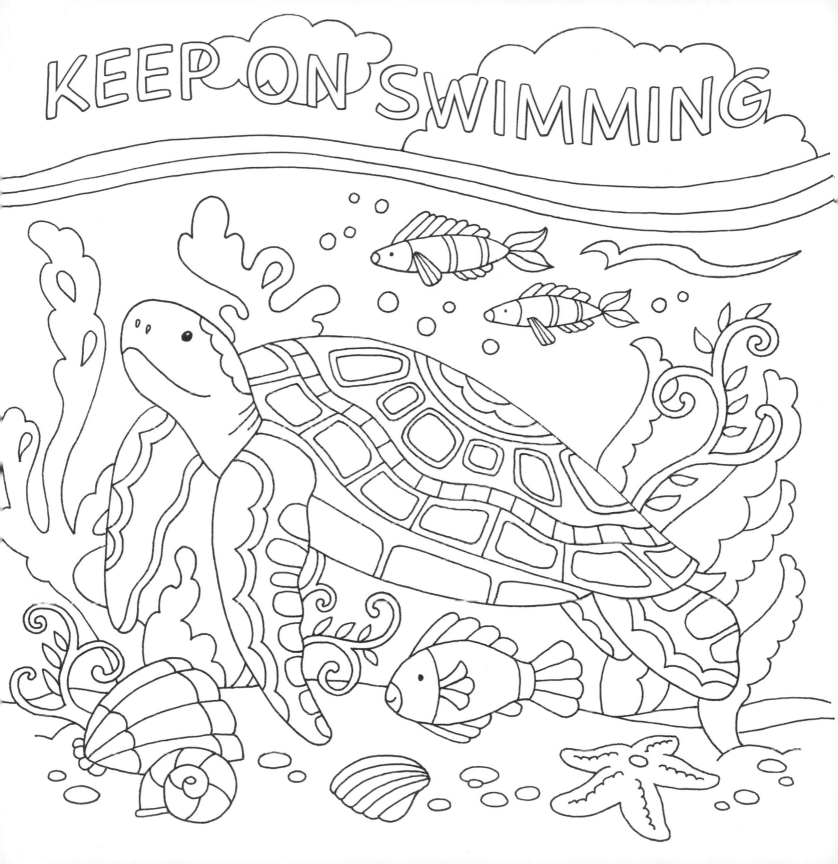

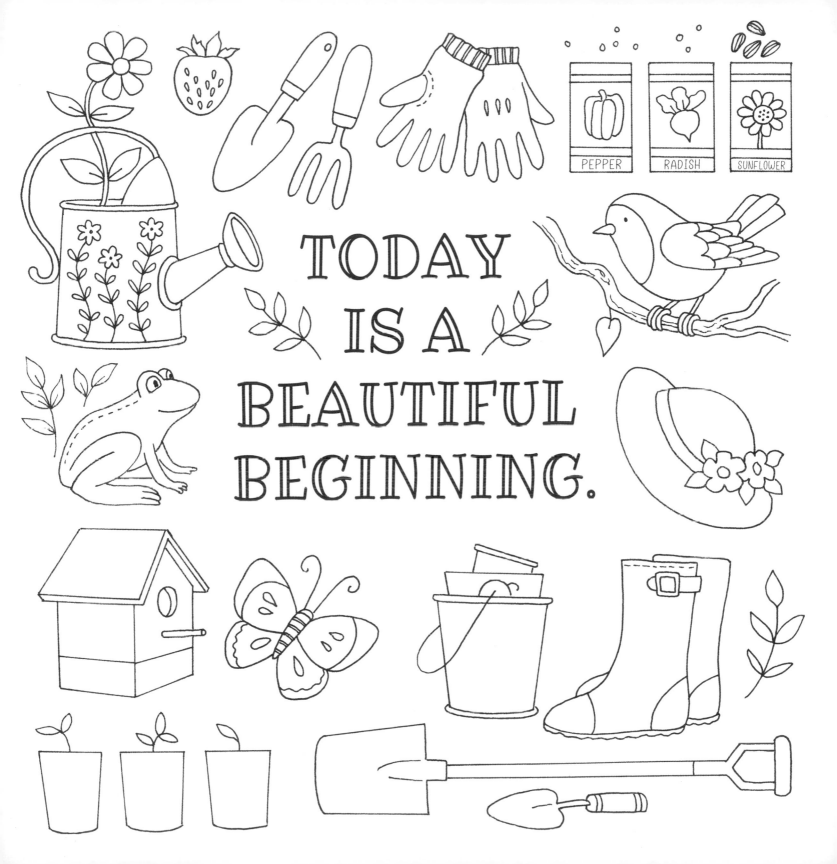

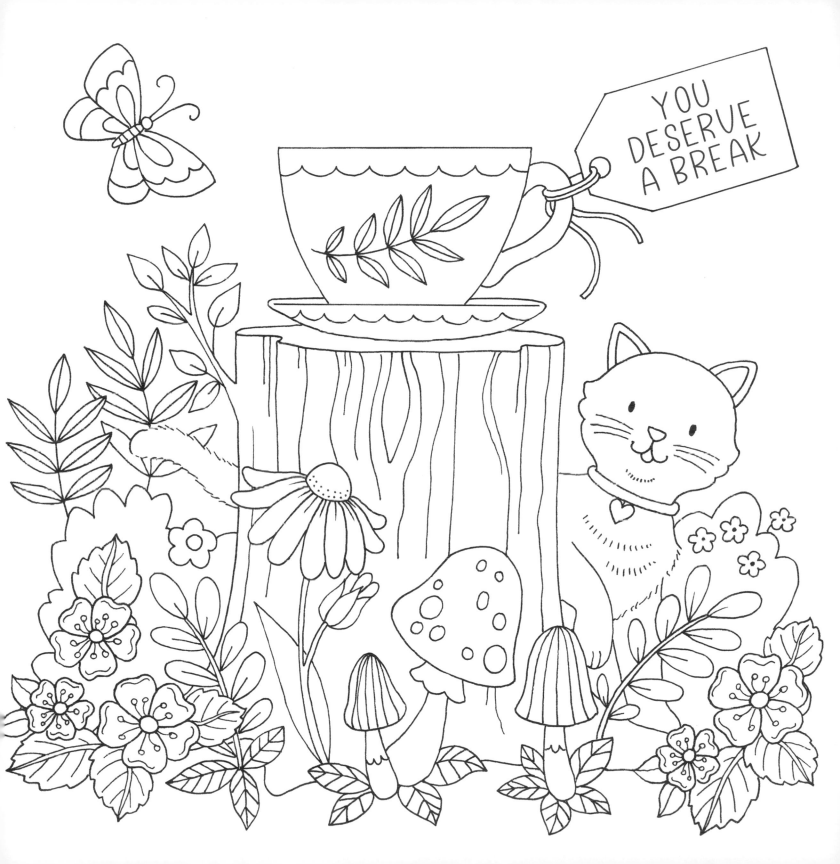

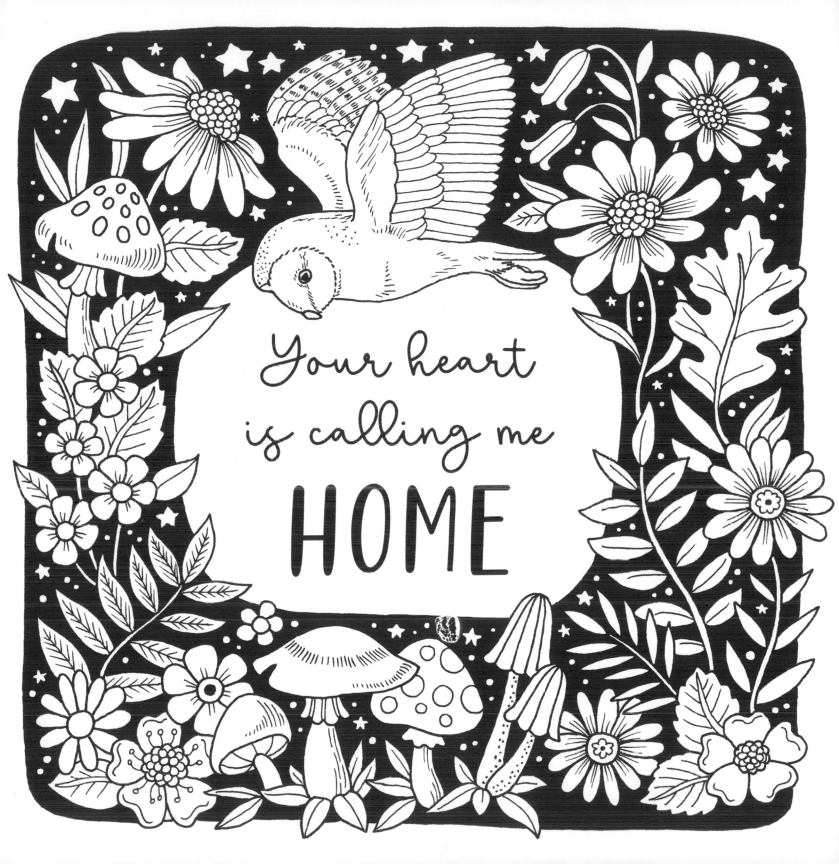

Your heart
is calling me
HOME

REMINDERS

Today is the perfect day to lay down your burdens.

Sometimes life is just about showing up.

A little bit of kindness can go a long way.

FORGET ME NOT

YOU'VE GOT THIS

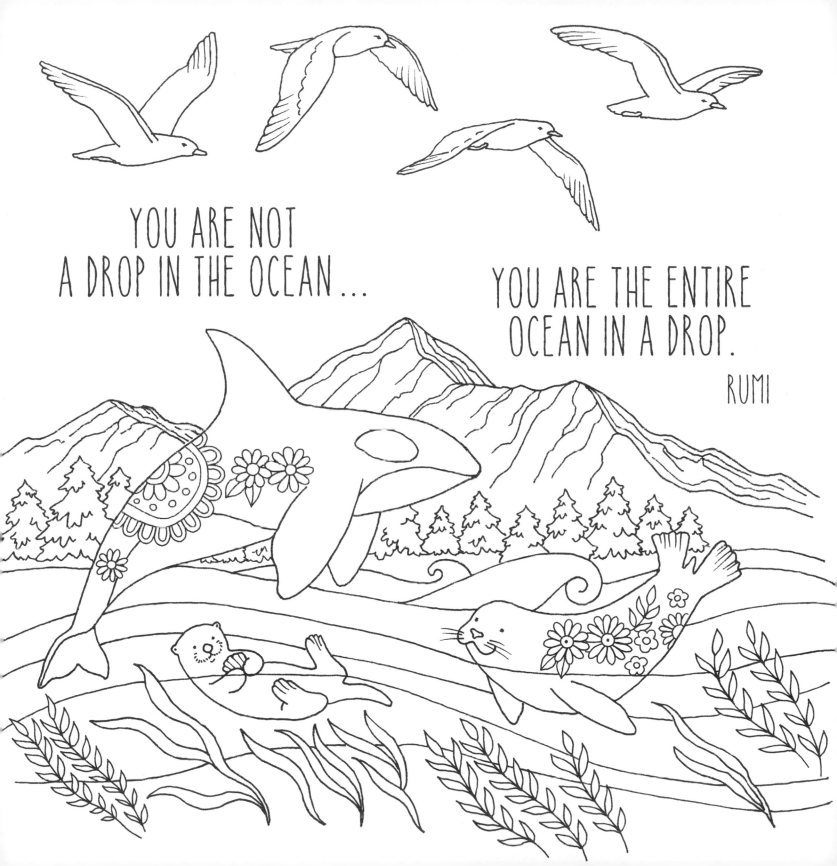

YOU ARE NOT
A DROP IN THE OCEAN...

YOU ARE THE ENTIRE
OCEAN IN A DROP.

RUMI

I THINK I'LL JUST BE COZY TODAY

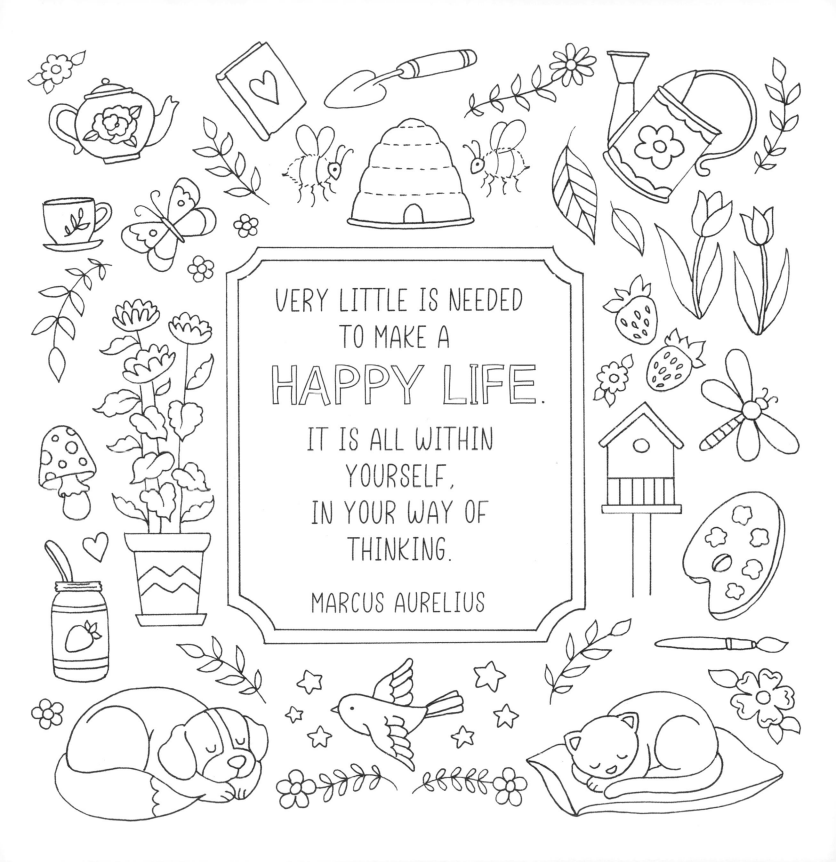

VERY LITTLE IS NEEDED
TO MAKE A
HAPPY LIFE.
IT IS ALL WITHIN
YOURSELF,
IN YOUR WAY OF
THINKING.

MARCUS AURELIUS

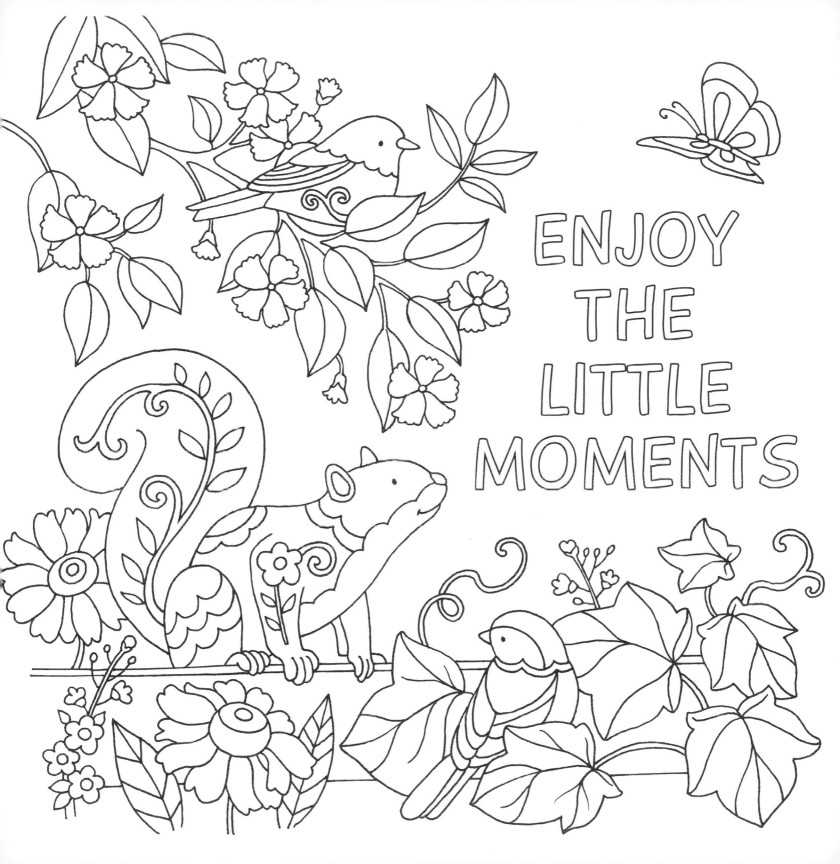

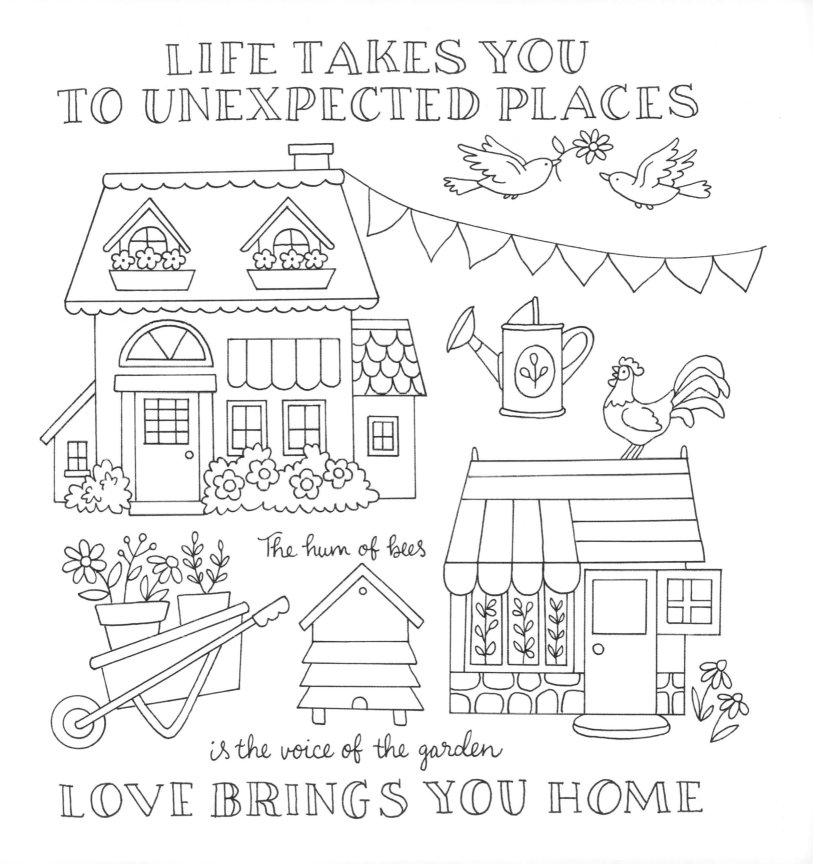

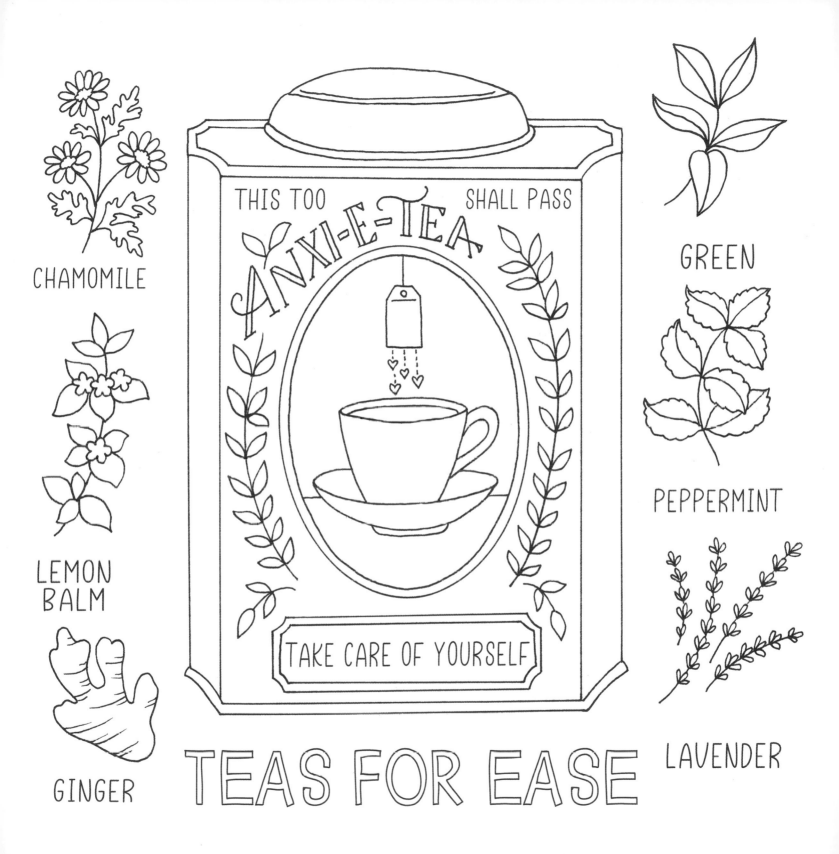

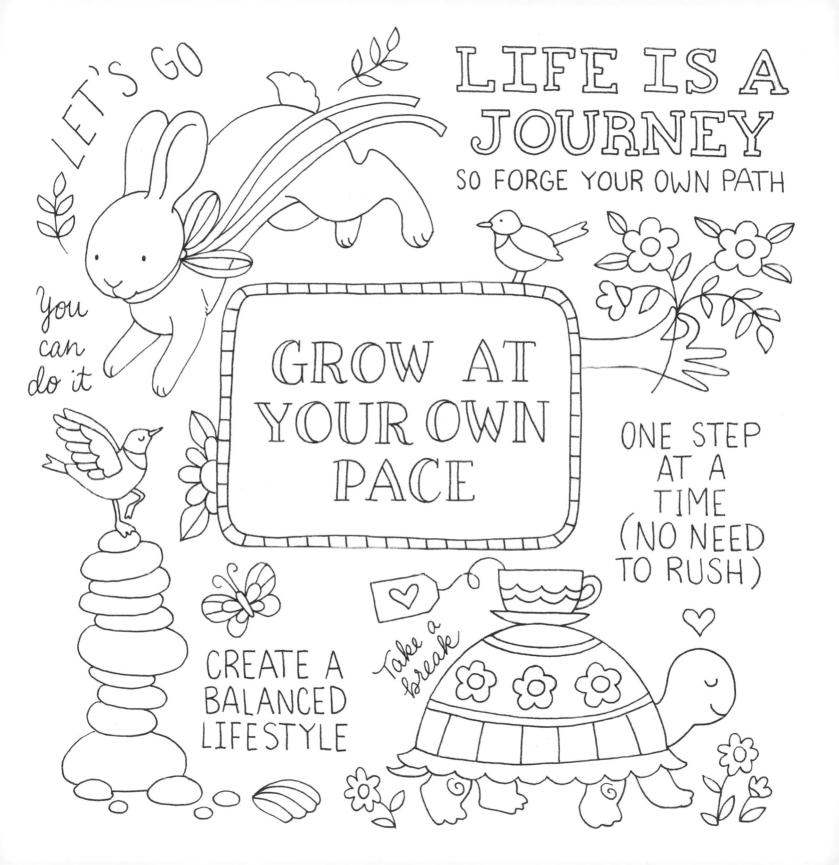

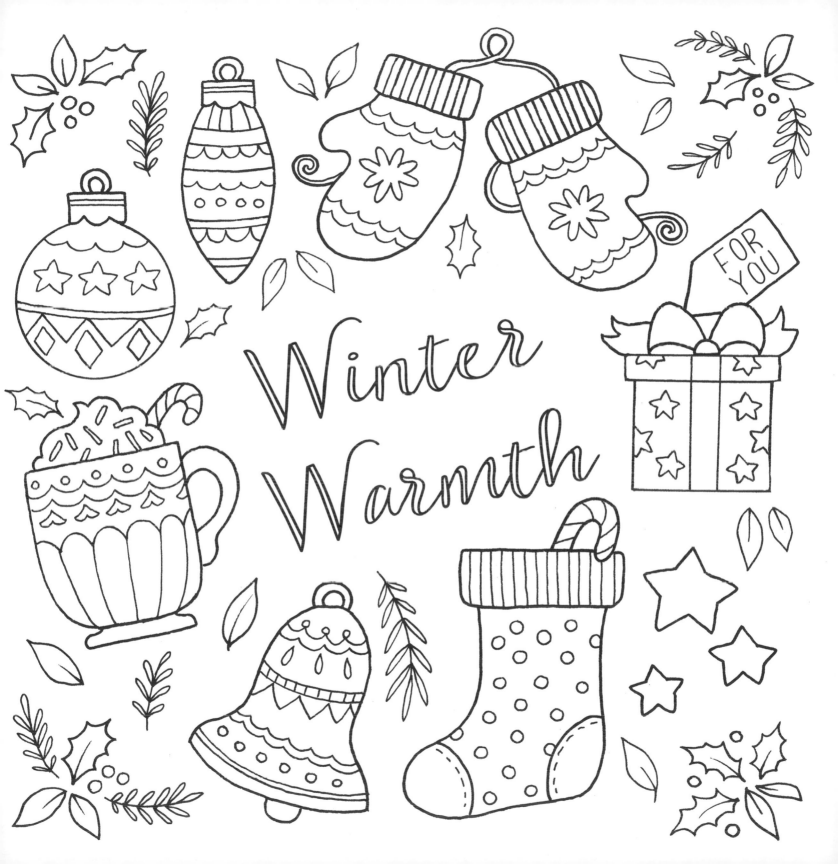

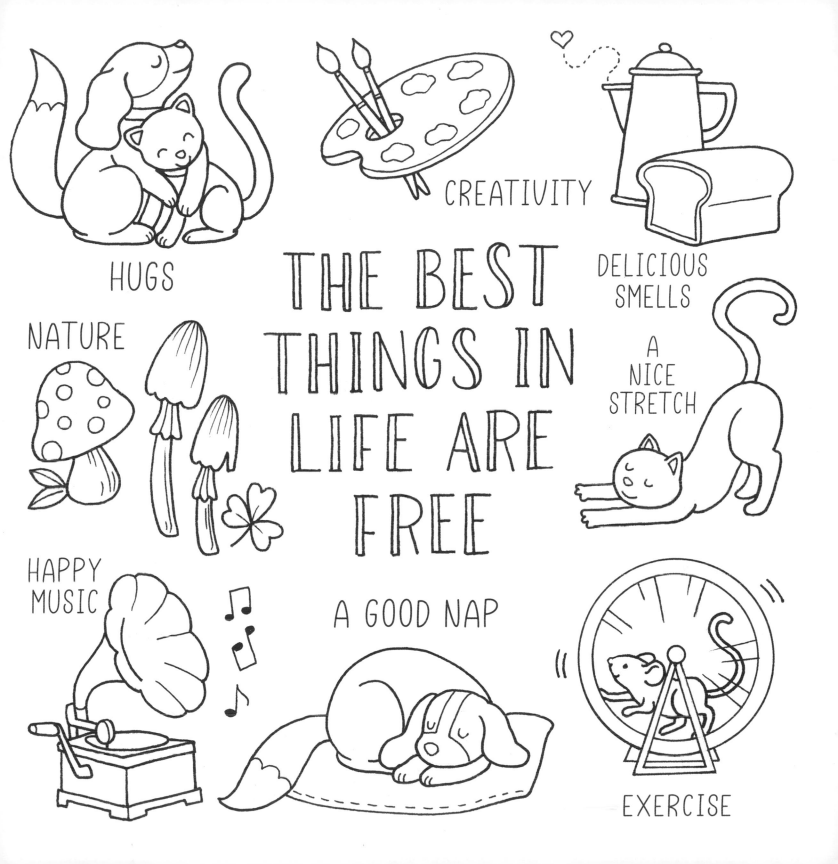

HUGS

CREATIVITY

DELICIOUS SMELLS

NATURE

THE BEST THINGS IN LIFE ARE FREE

A NICE STRETCH

HAPPY MUSIC

A GOOD NAP

EXERCISE

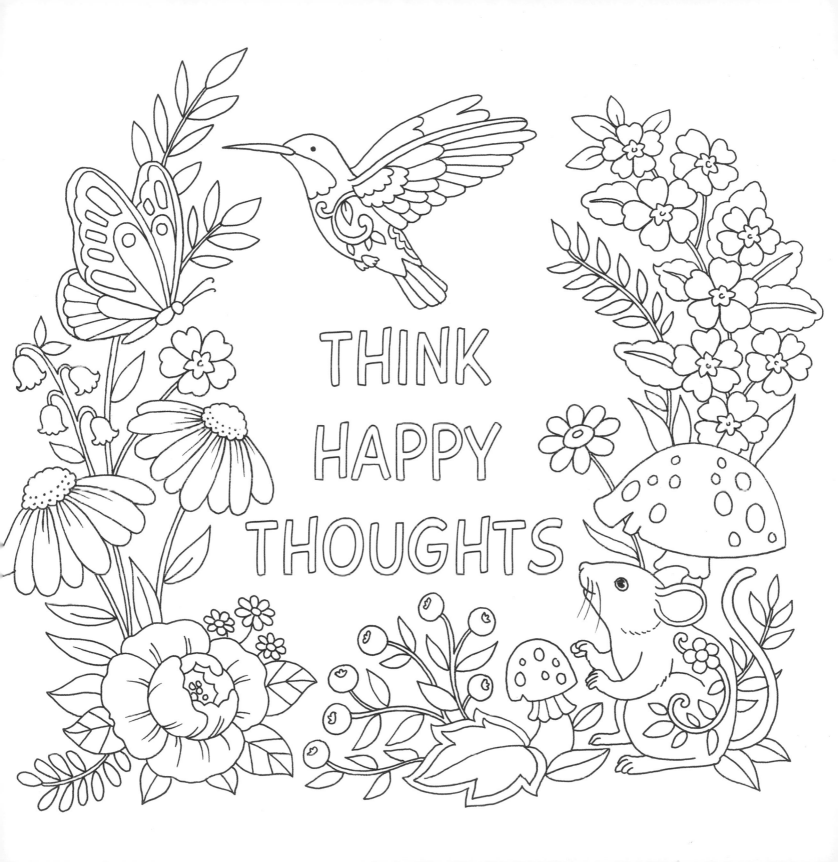

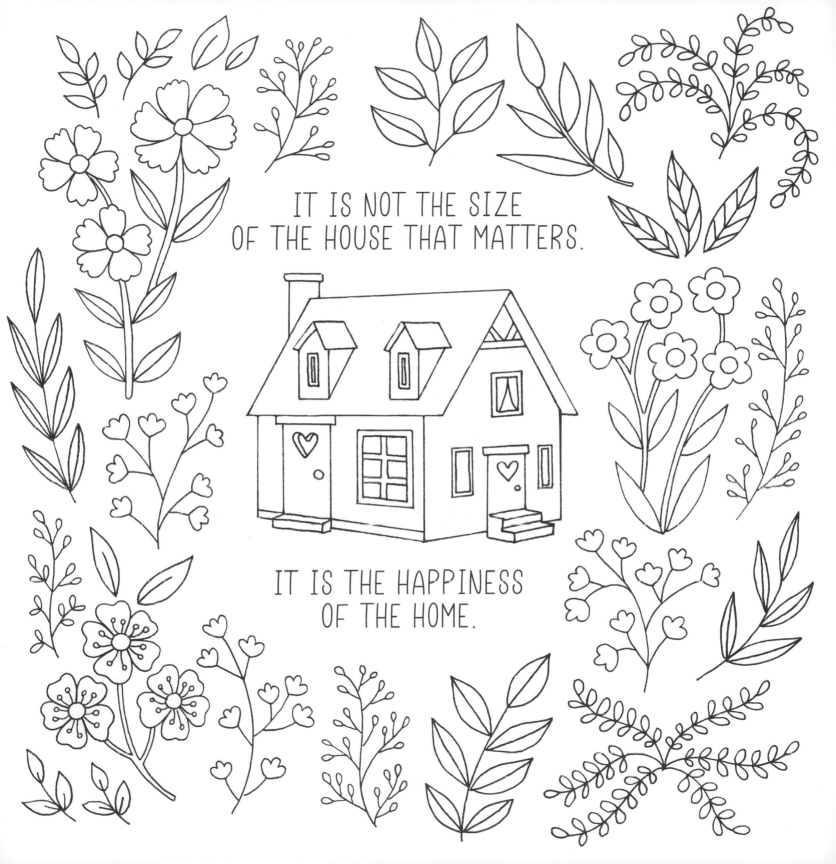

IT IS NOT THE SIZE
OF THE HOUSE THAT MATTERS.

IT IS THE HAPPINESS
OF THE HOME.

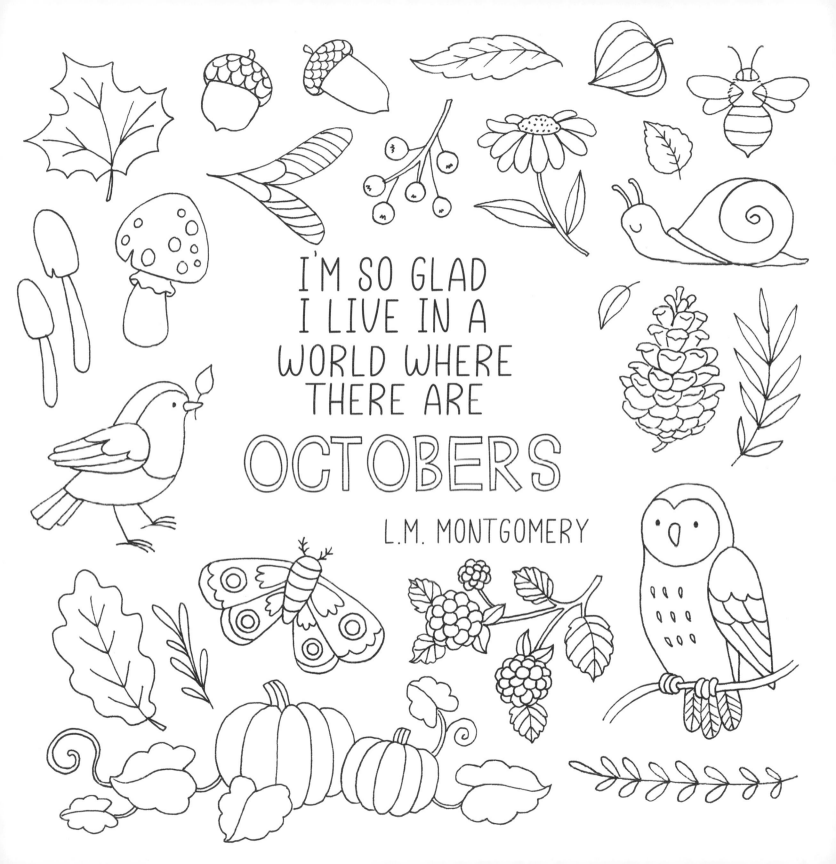

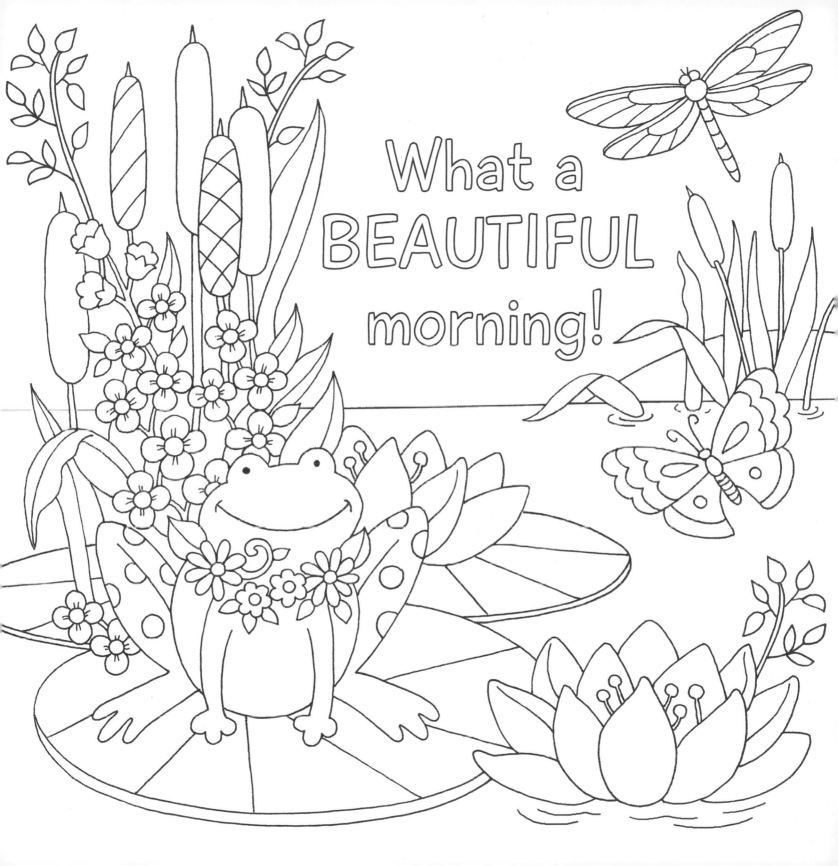

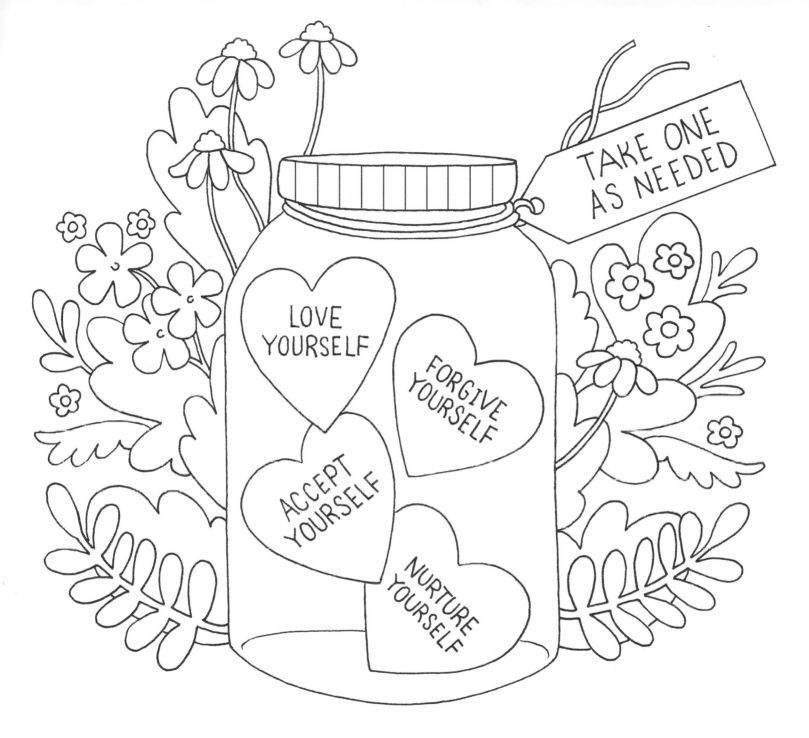

WHEN YOU FEEL SAD

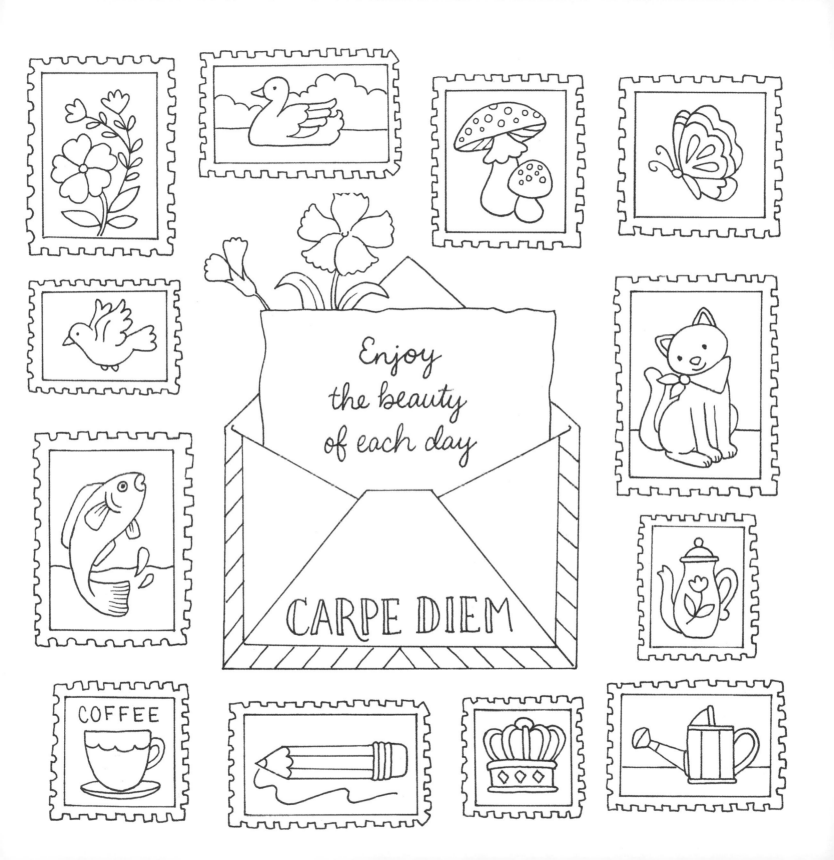

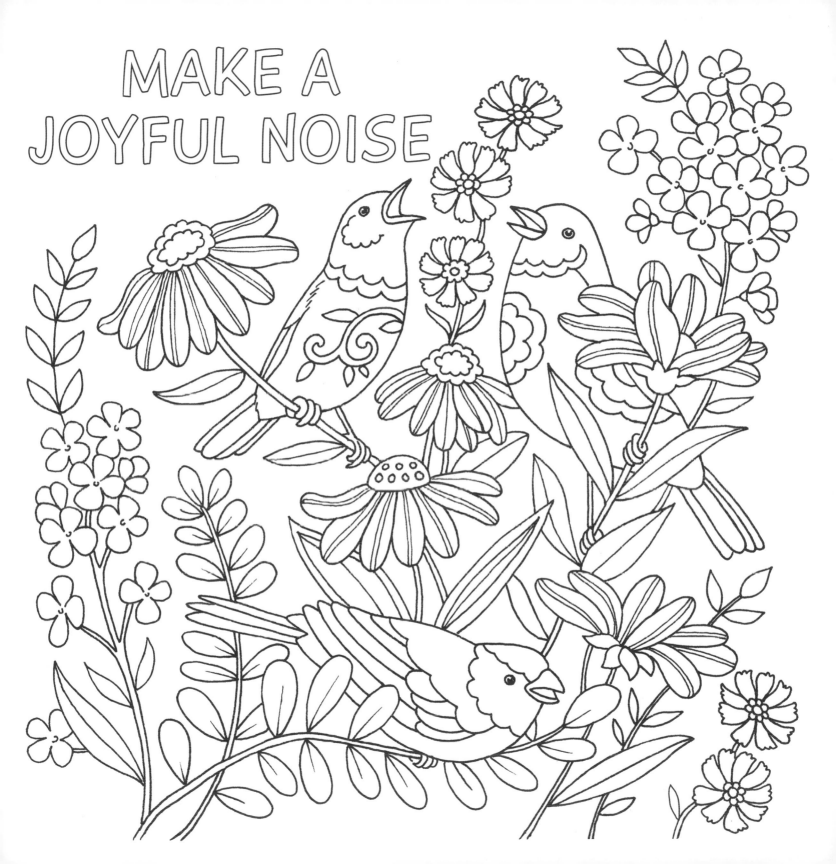

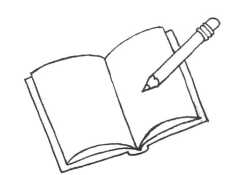

JOURNAL
THOUGHTS
AND
FEELINGS

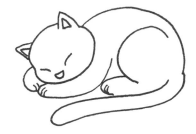

GET ENOUGH REST

EAT HEALTHY
FOOD

TAKE
BREAKS

CELEBRATE
THE LITTLE THINGS

HYDRATE

LEARN
NEW THINGS

PRACTICE
CREATIVITY

EXERCISE

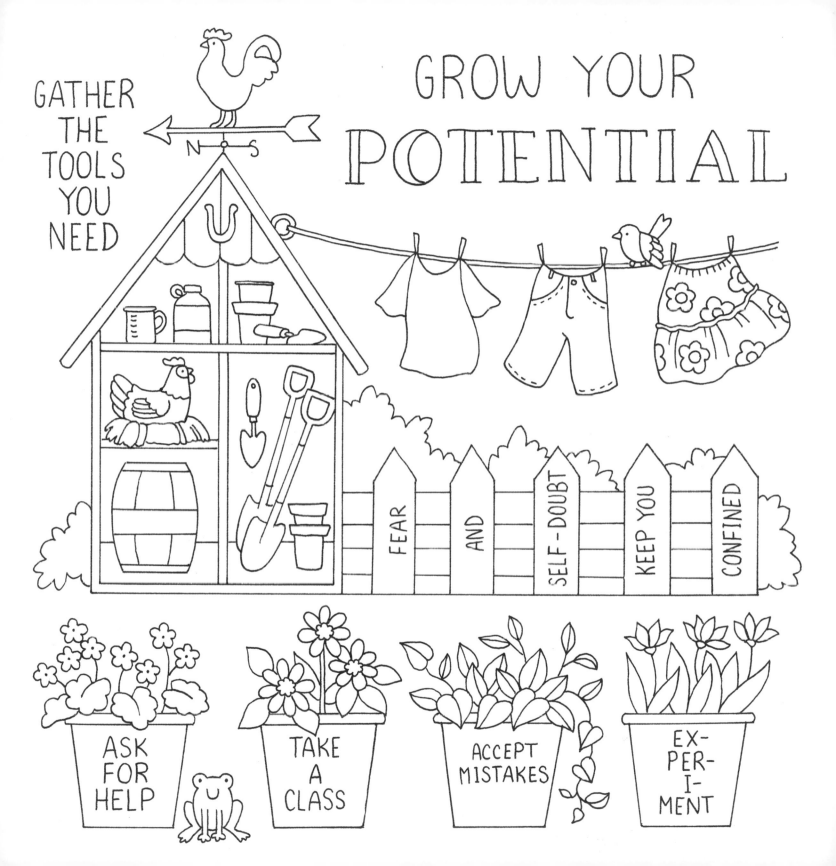

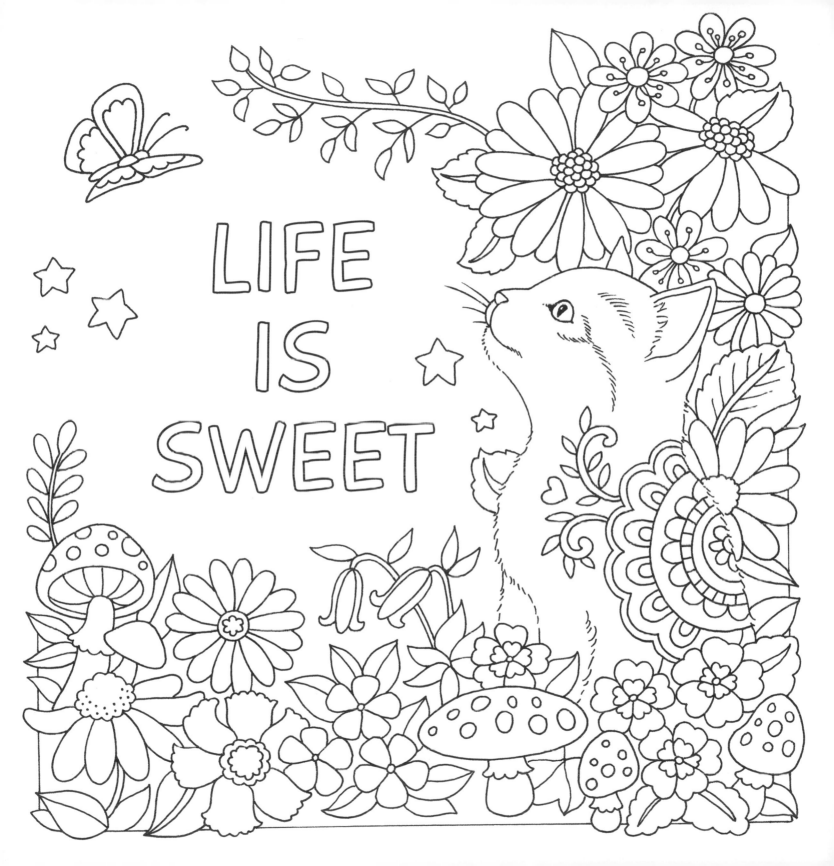

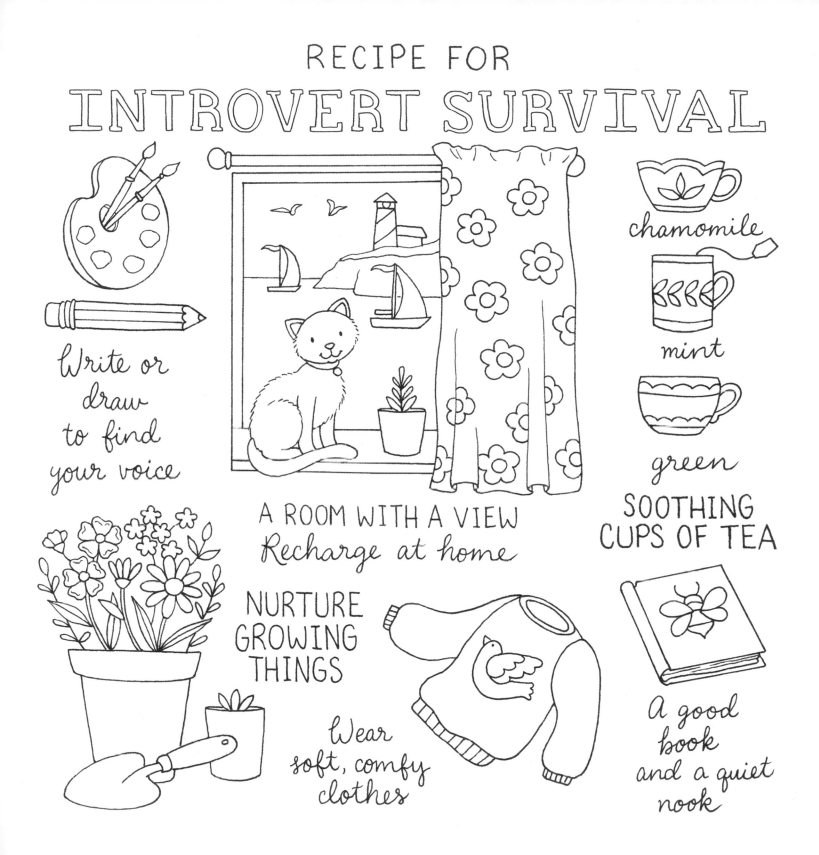

RECIPE FOR
INTROVERT SURVIVAL

Write or draw to find your voice

chamomile

mint

green

SOOTHING CUPS OF TEA

A ROOM WITH A VIEW
Recharge at home

NURTURE GROWING THINGS

Wear soft, comfy clothes

A good book and a quiet nook

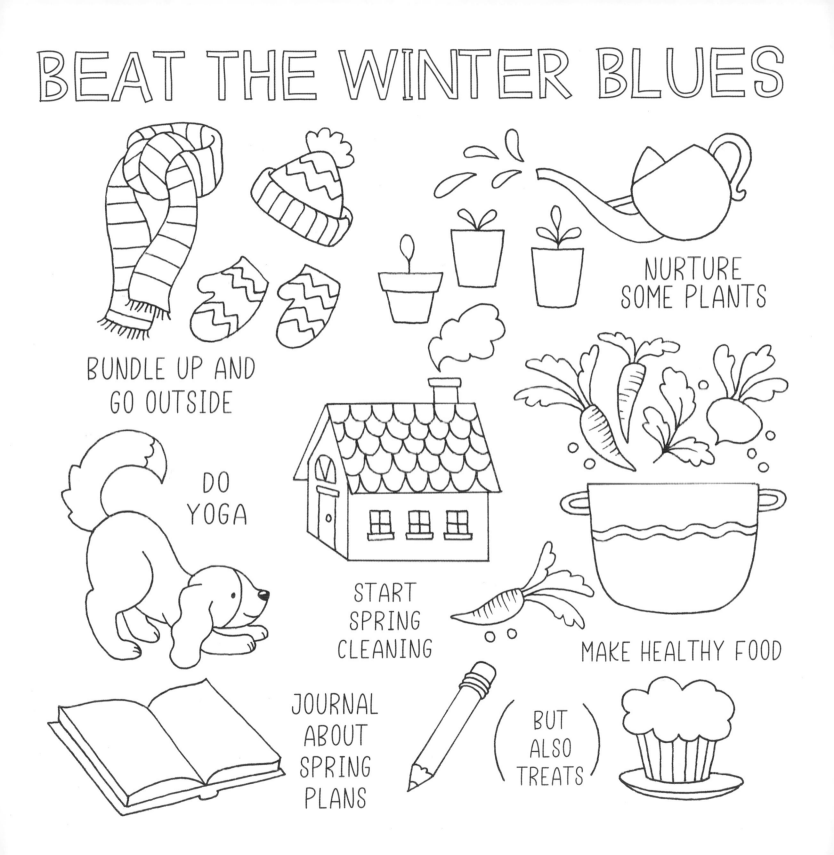

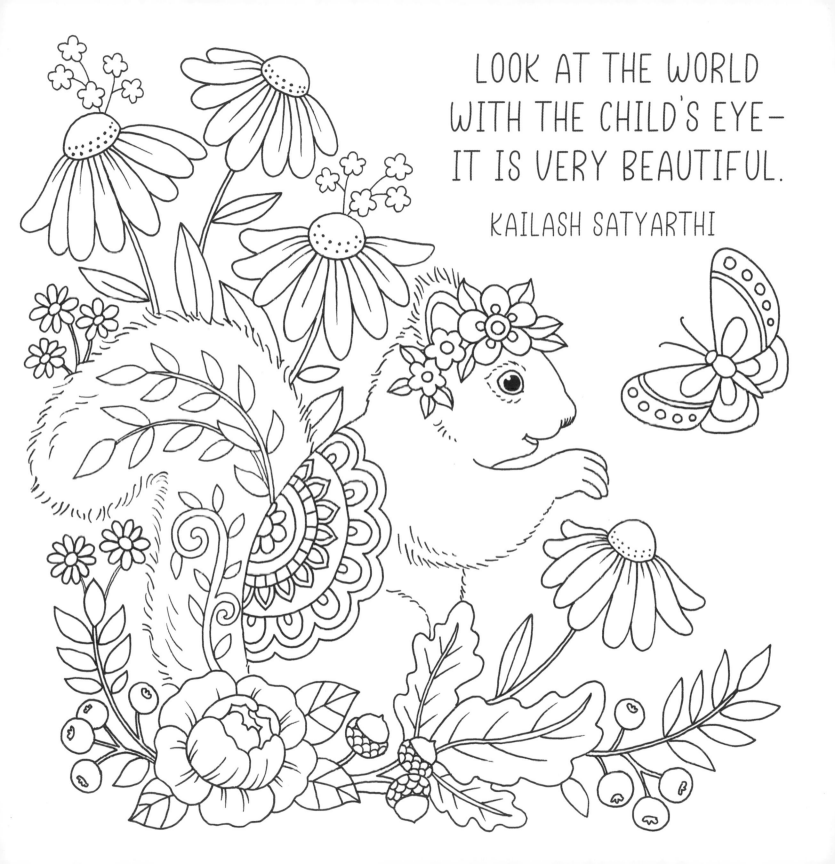

LOOK AT THE WORLD
WITH THE CHILD'S EYE—
IT IS VERY BEAUTIFUL.

KAILASH SATYARTHI

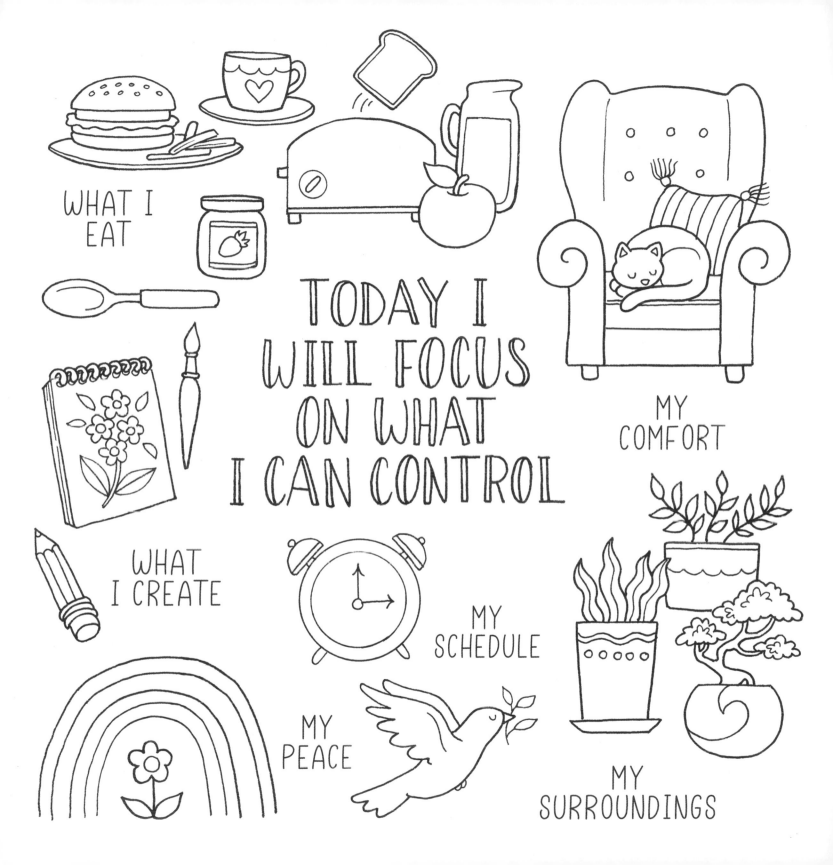

WHAT I EAT

TODAY I WILL FOCUS ON WHAT I CAN CONTROL

MY COMFORT

WHAT I CREATE

MY SCHEDULE

MY PEACE

MY SURROUNDINGS

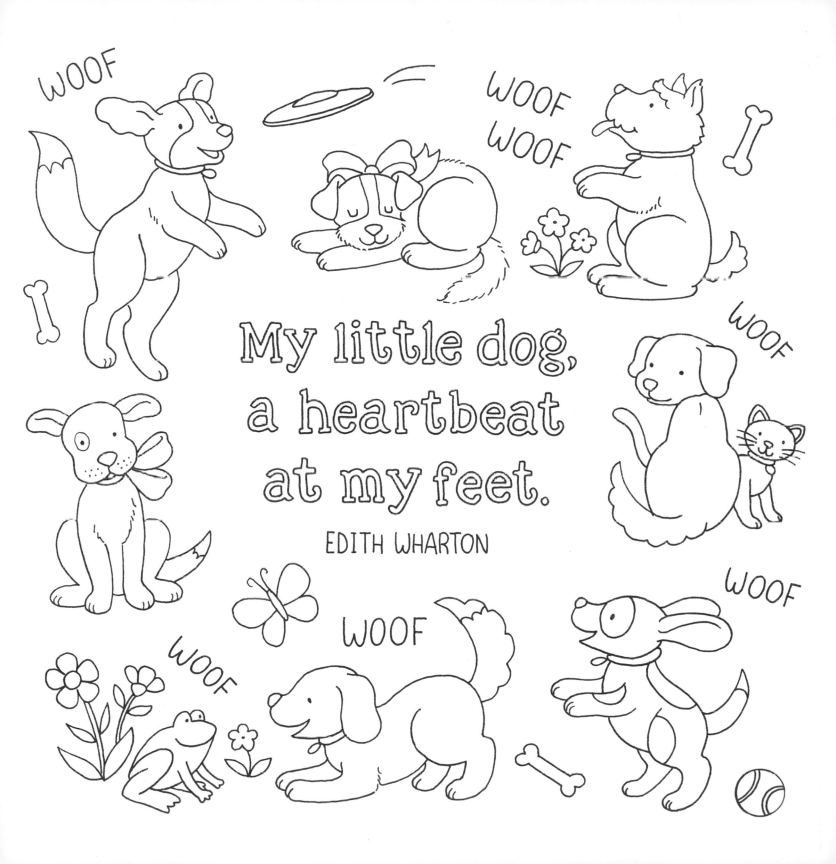

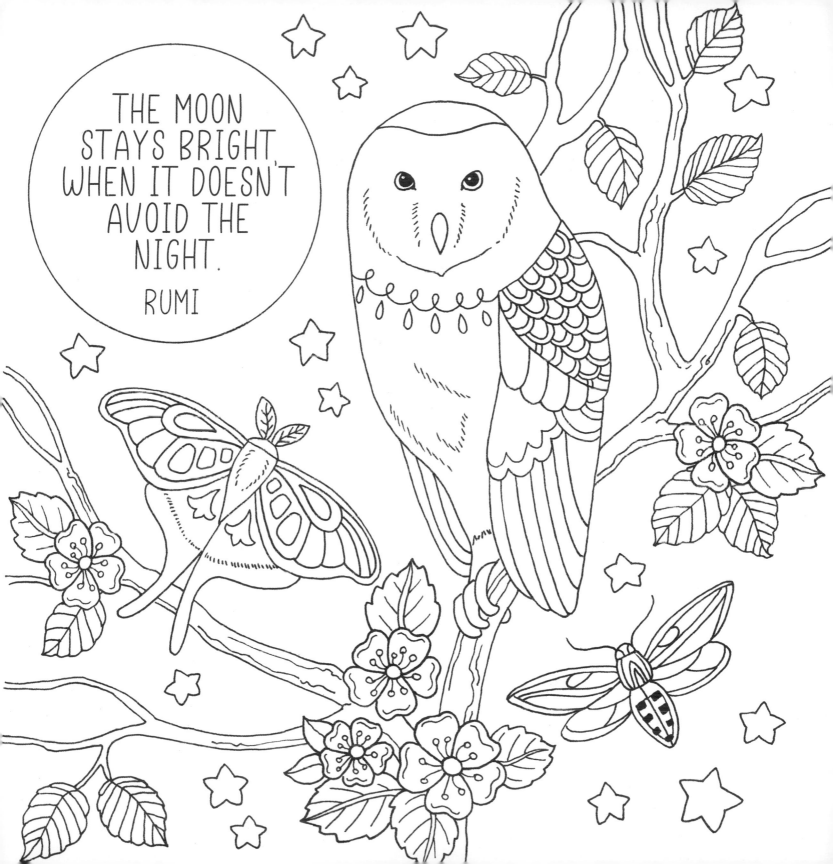

THE MOON STAYS BRIGHT WHEN IT DOESN'T AVOID THE NIGHT.

RUMI

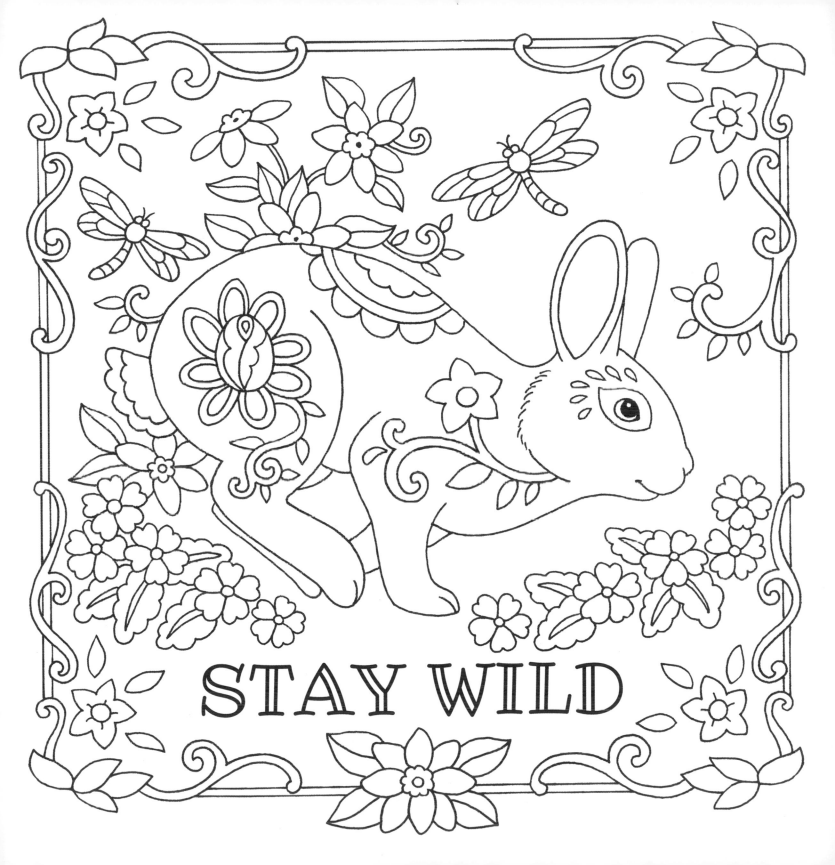

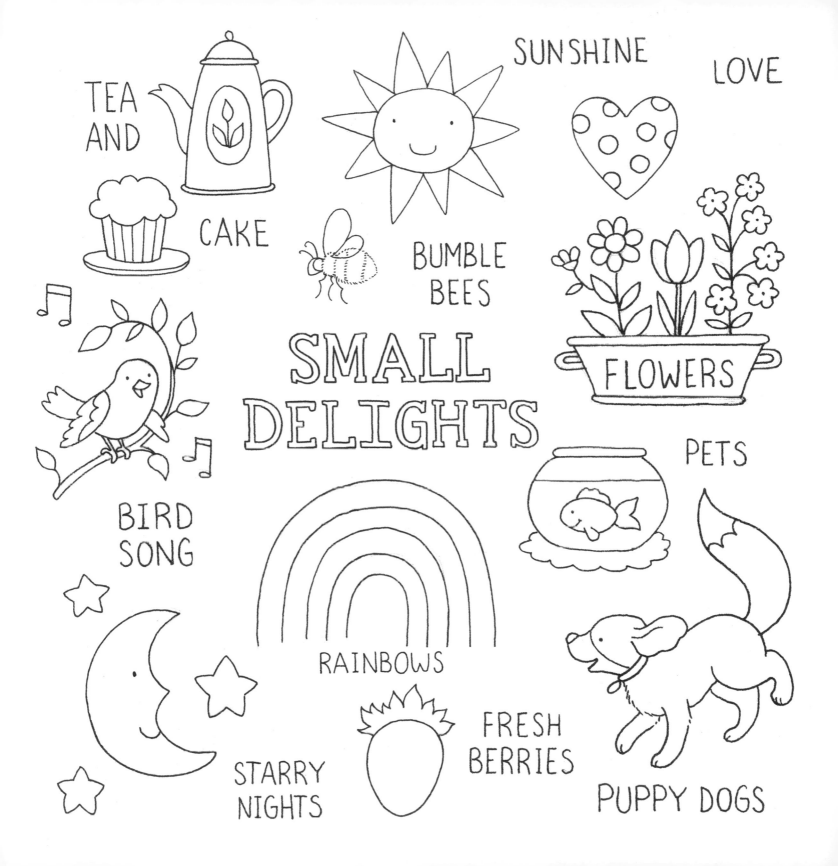

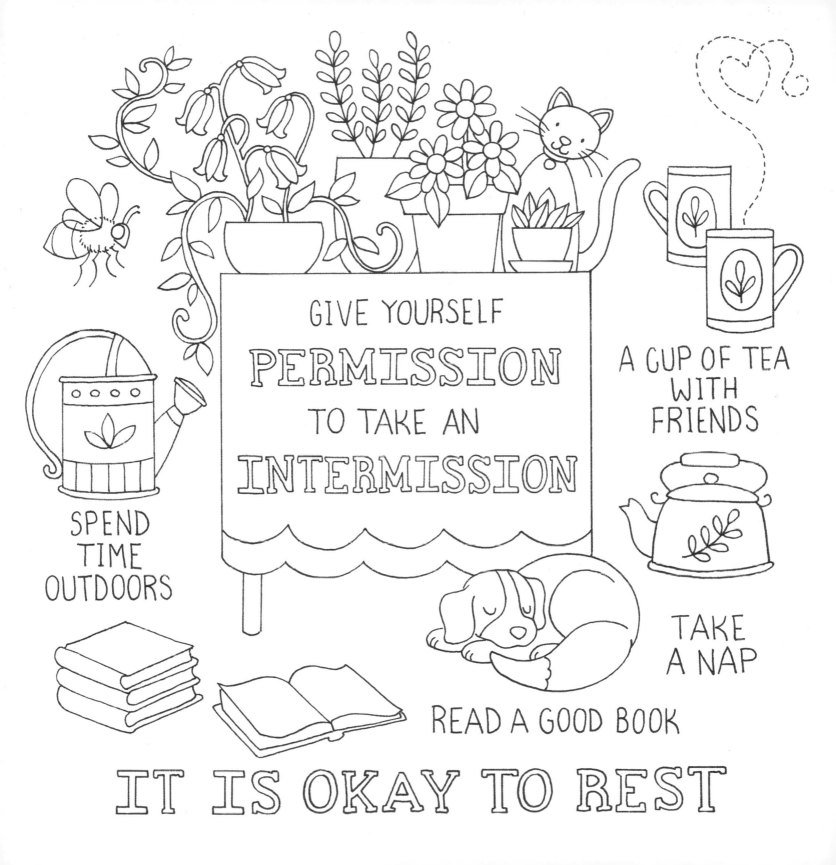

SIMPLE JOYS OF LIFE

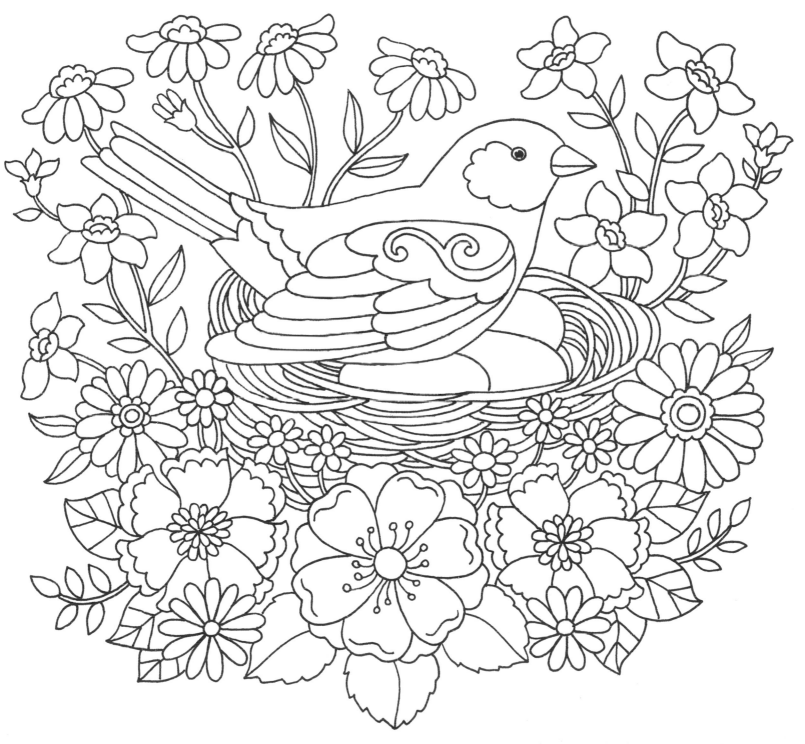

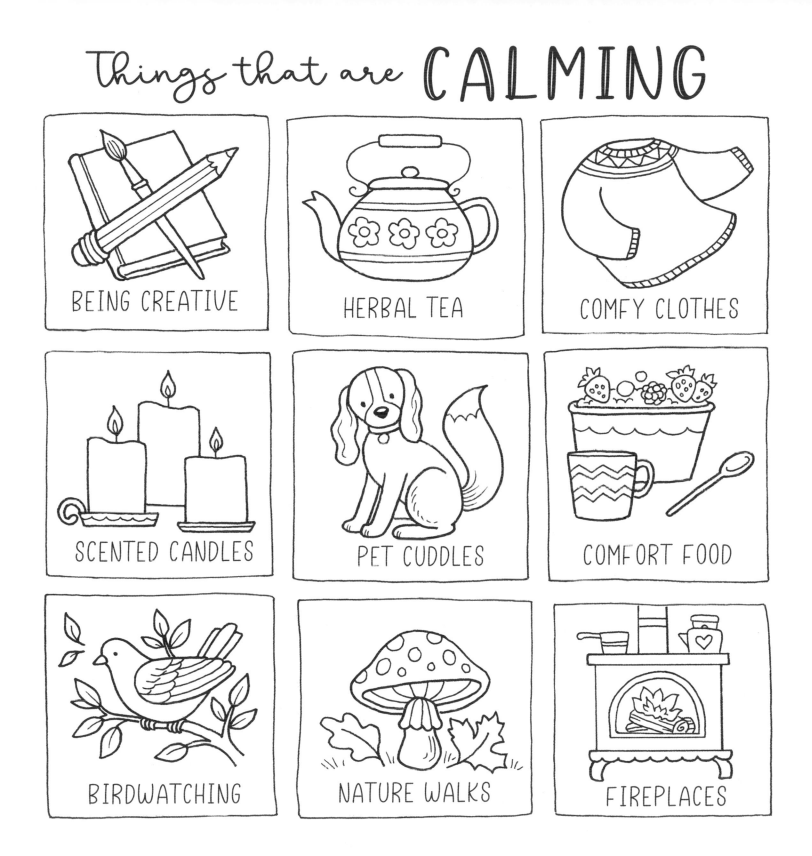

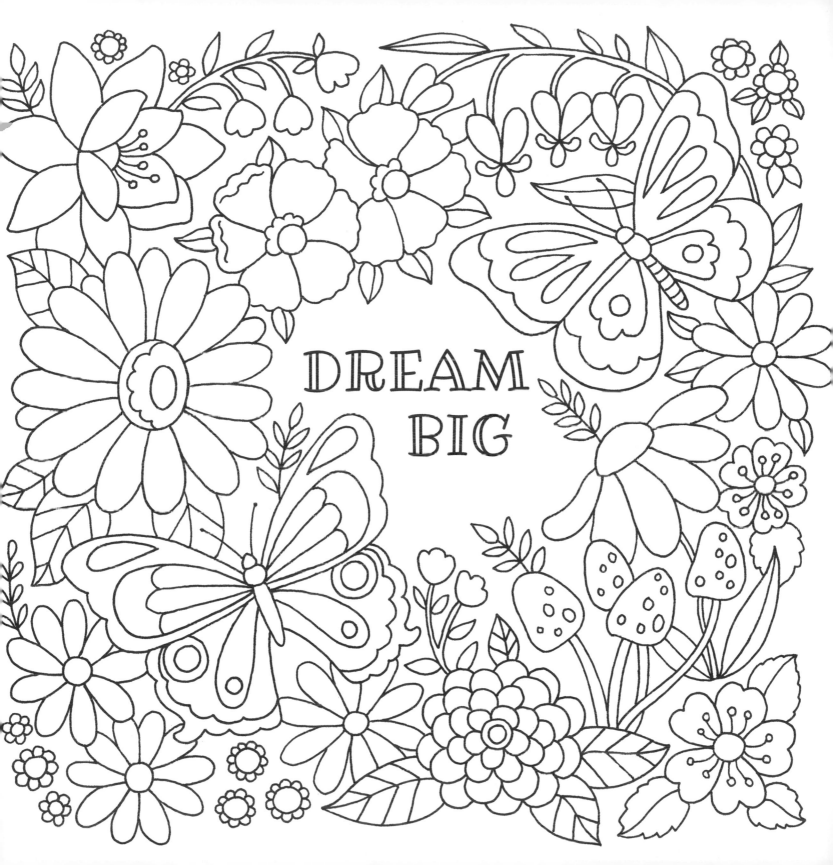

About the Artist

Jane Maday began her career at fourteen, as a scientific illustrator for the University of Florida. After receiving a bachelor's degree from Ringling College of Art and Design, she was recruited by Hallmark Cards, Inc. as an illustrator. Jane left the corporate world after her children were born and moved to beautiful Colorado. Her work has adorned books, collector plates, ornaments, T-shirts, garden flags, jigsaw puzzles, and much more. Jane has two children, a menagerie of animals, a garden for inspiration, and a husband to share it all.

Enjoy Jane Maday's other Get Creative 6 coloring books, *Nature's Sweet Moments* and *The Art of Positivity*, as well as her creativity and how-to-draw books, *Everyday Art Exercises* and *How to Journal Like an Artist*.

Get Creative 6
An Imprint of Mixed Media Resources
19 West 21st Street, Suite 601, New York, NY 10010
Sixthandspringbooks.com

Chairman: Jay Stein
President: Art Joinnides
Chief Executive Officer: Caroline Kilmer
Editor: Pam Kingsley
Creative Director: Irene Ledwith
Art Director: Francesca Pacchini

Copyright © 2024 Jane Maday

All rights reserved. No part of this publication may be reproduced or used in any form or by any means—graphic, electronic, or mechanical, including photocopying, recording, or information storage-and-retrieval systems—without written permission of the publisher.

The written instructions, photographs, designs, projects, and patterns are intended for the personal, noncommercial use of the retail purchaser and are under federal copyright laws; they are not to be reproduced in any form for commercial use. Permission is granted to photocopy for the personal use of the retail purchaser.

Manufactured in China
1 3 5 7 9 10 8 6 4 2
First Edition